...ILLUSTRATED BY B.M. KING...

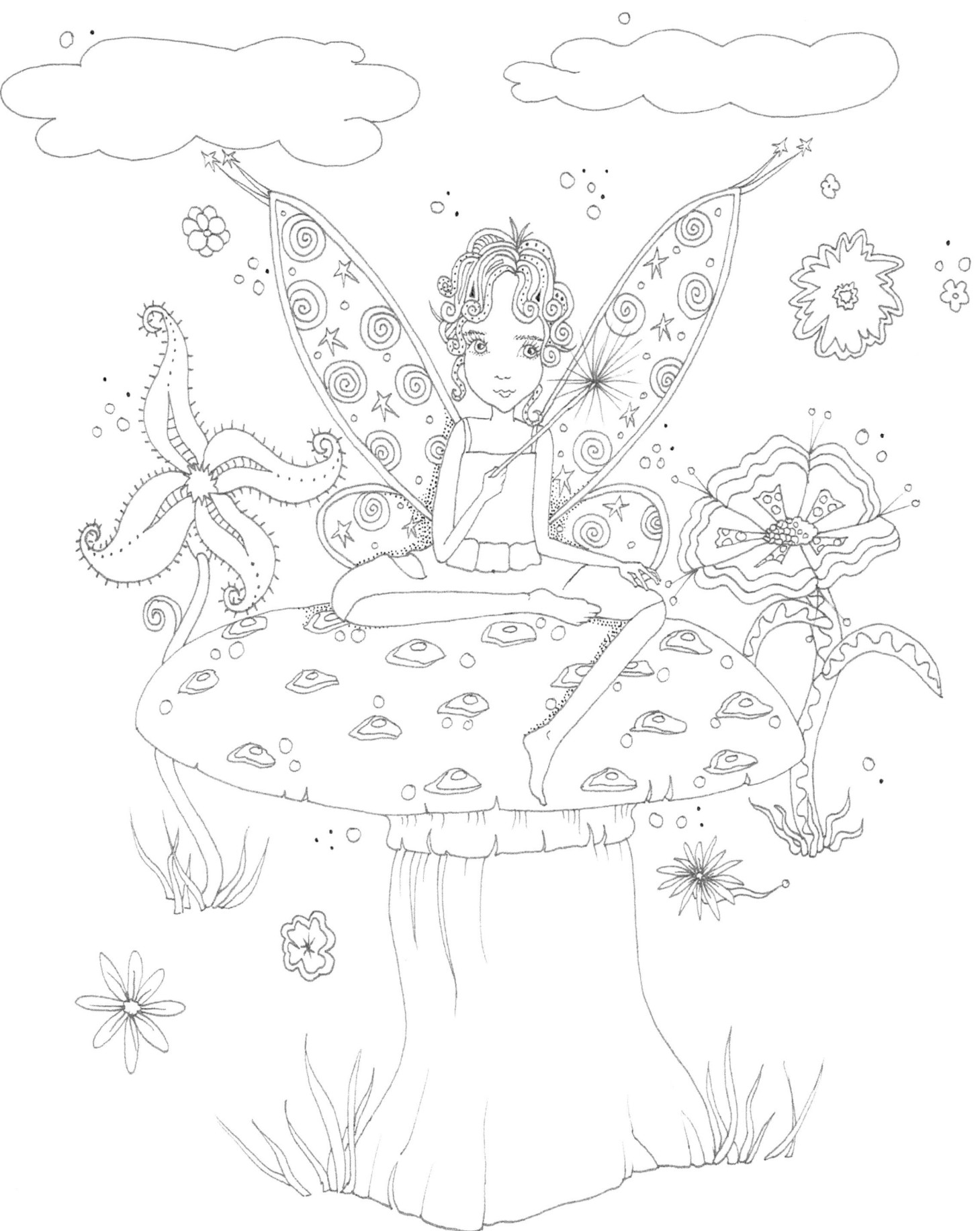

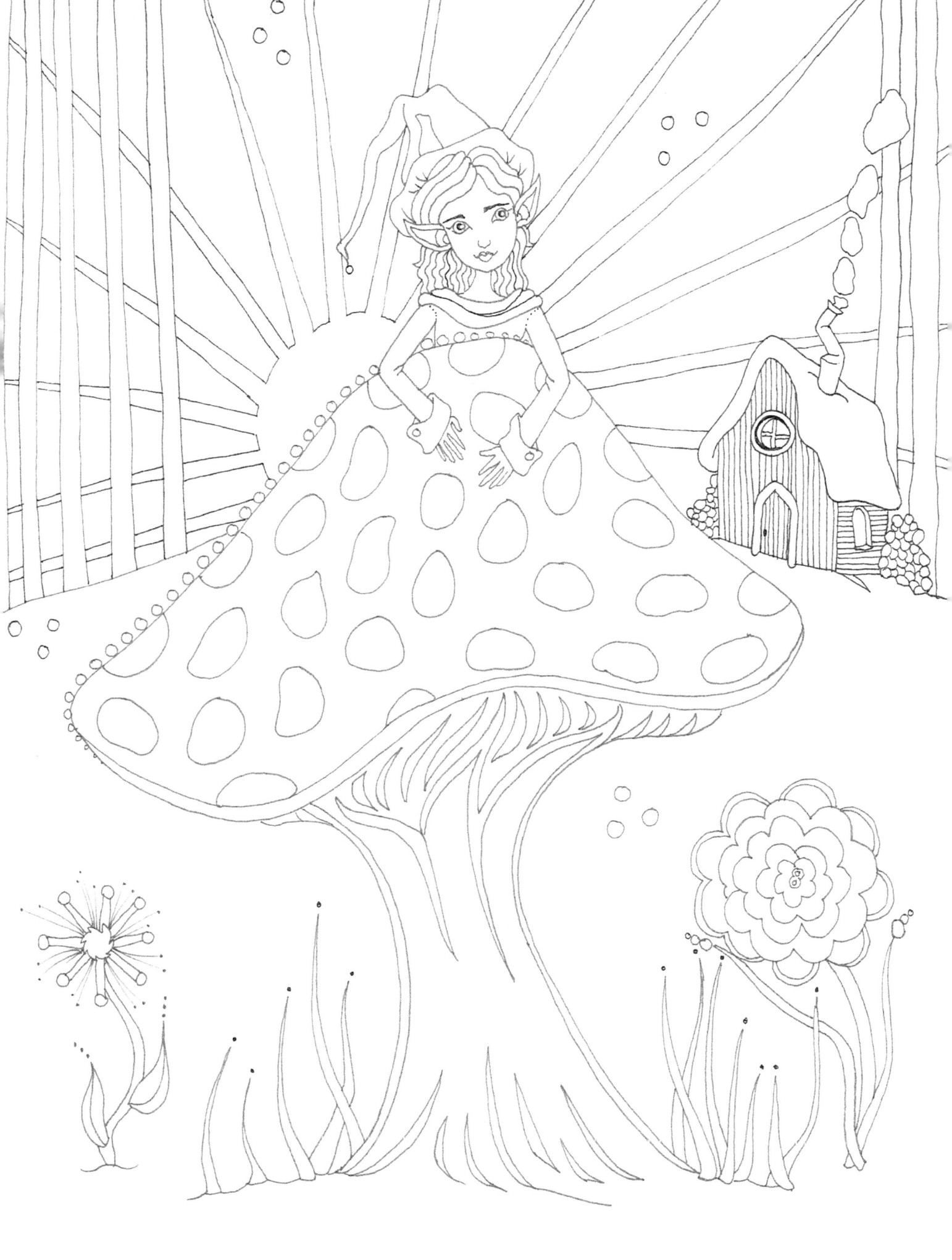

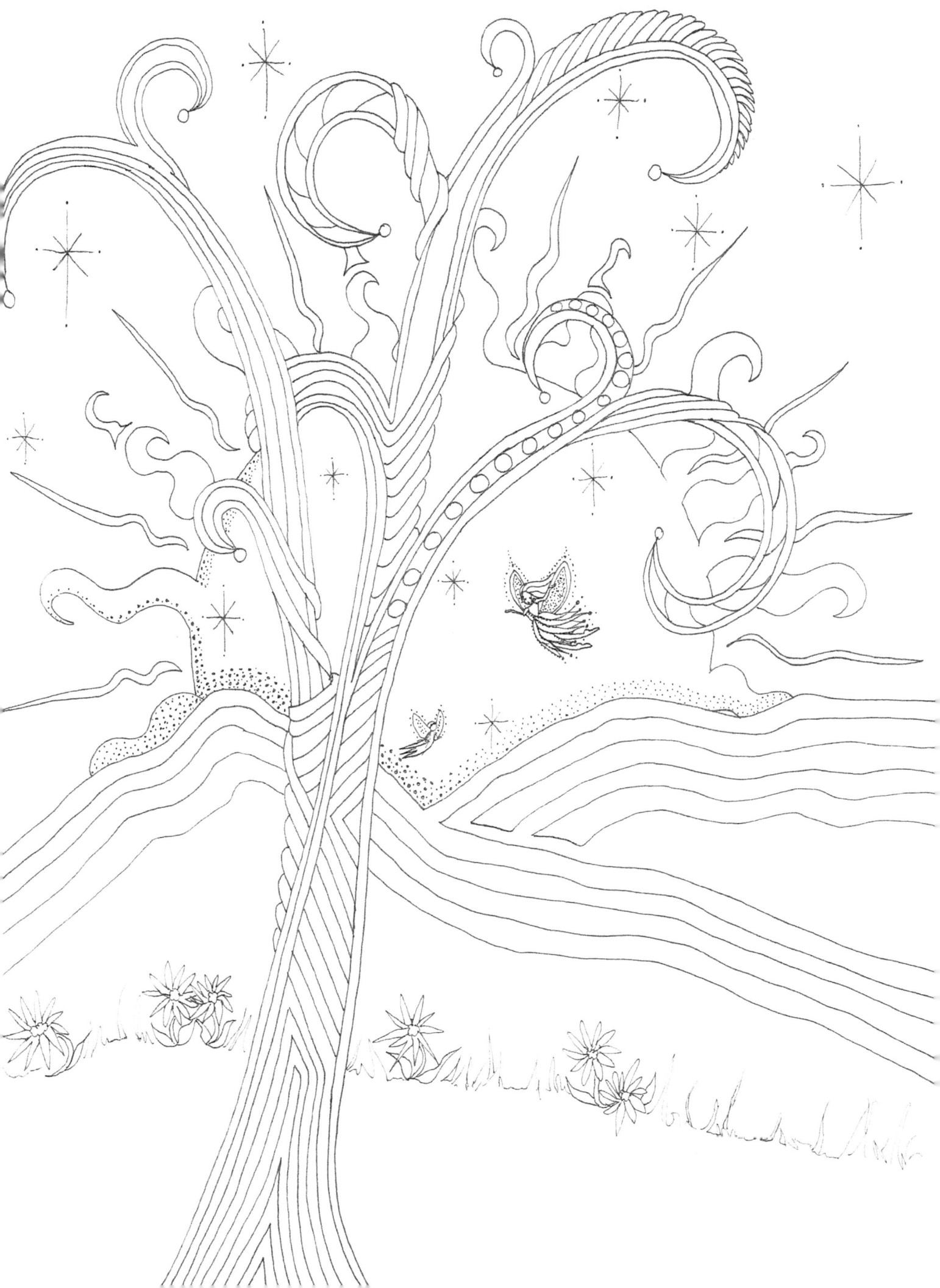

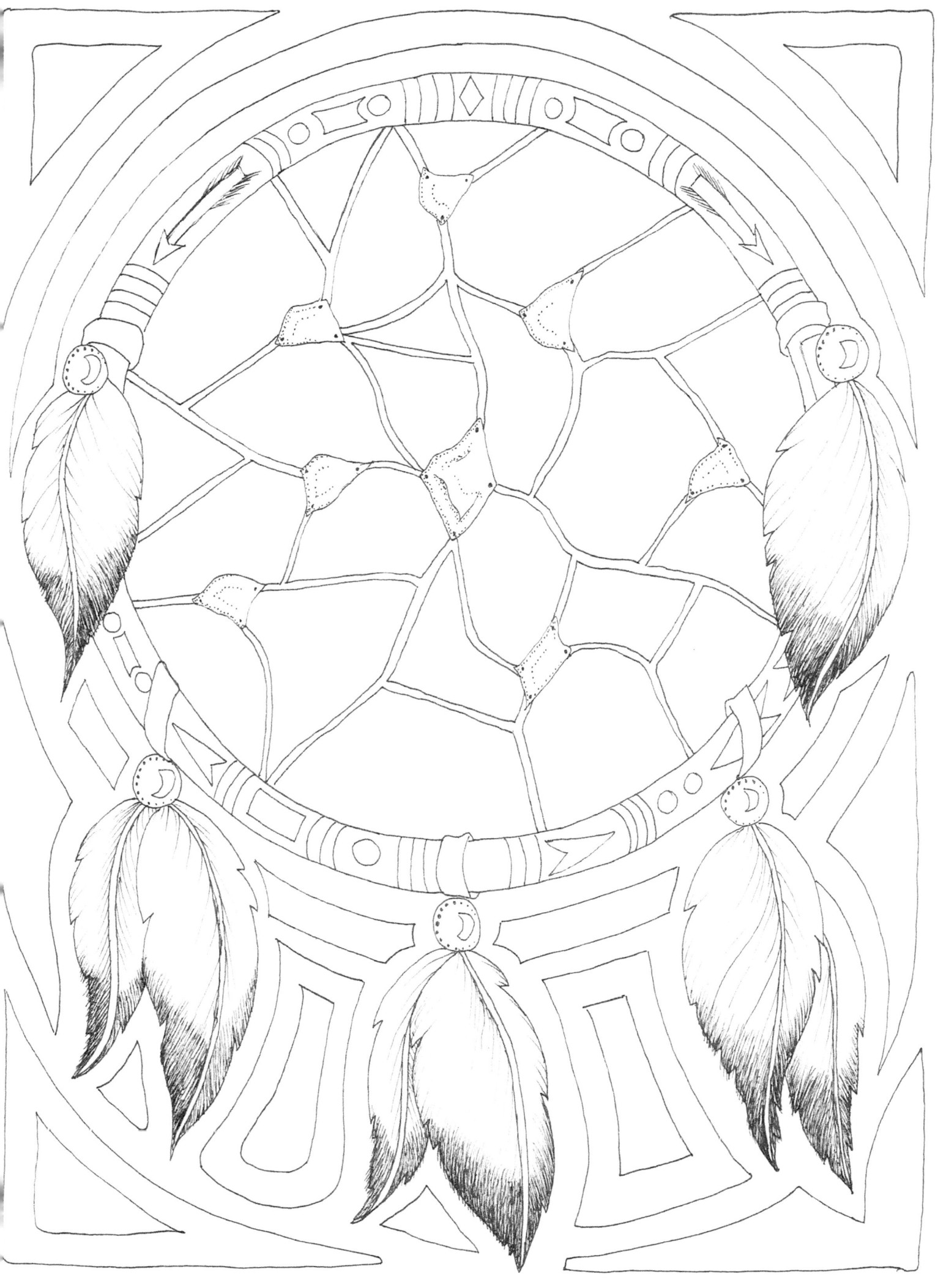

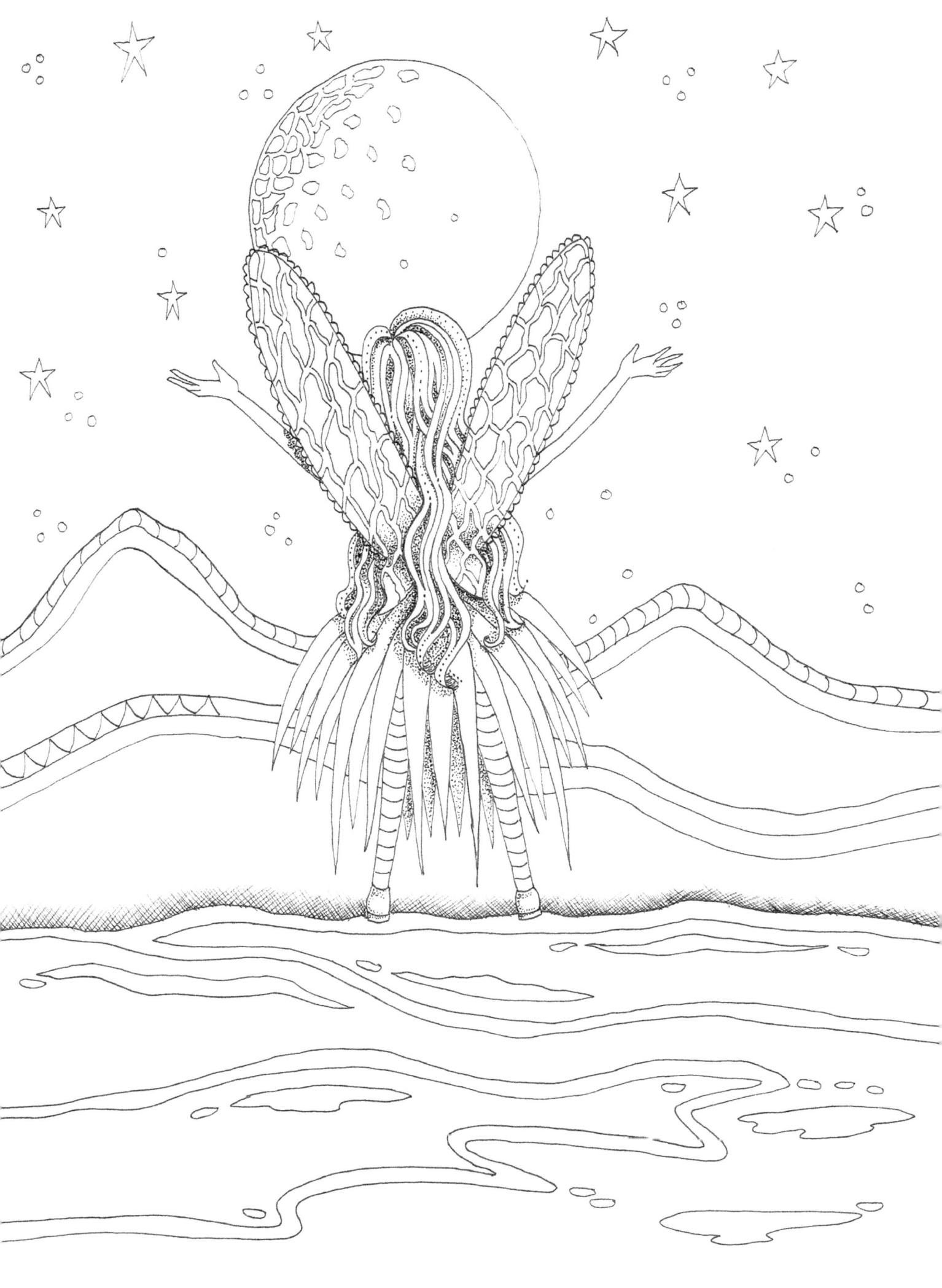

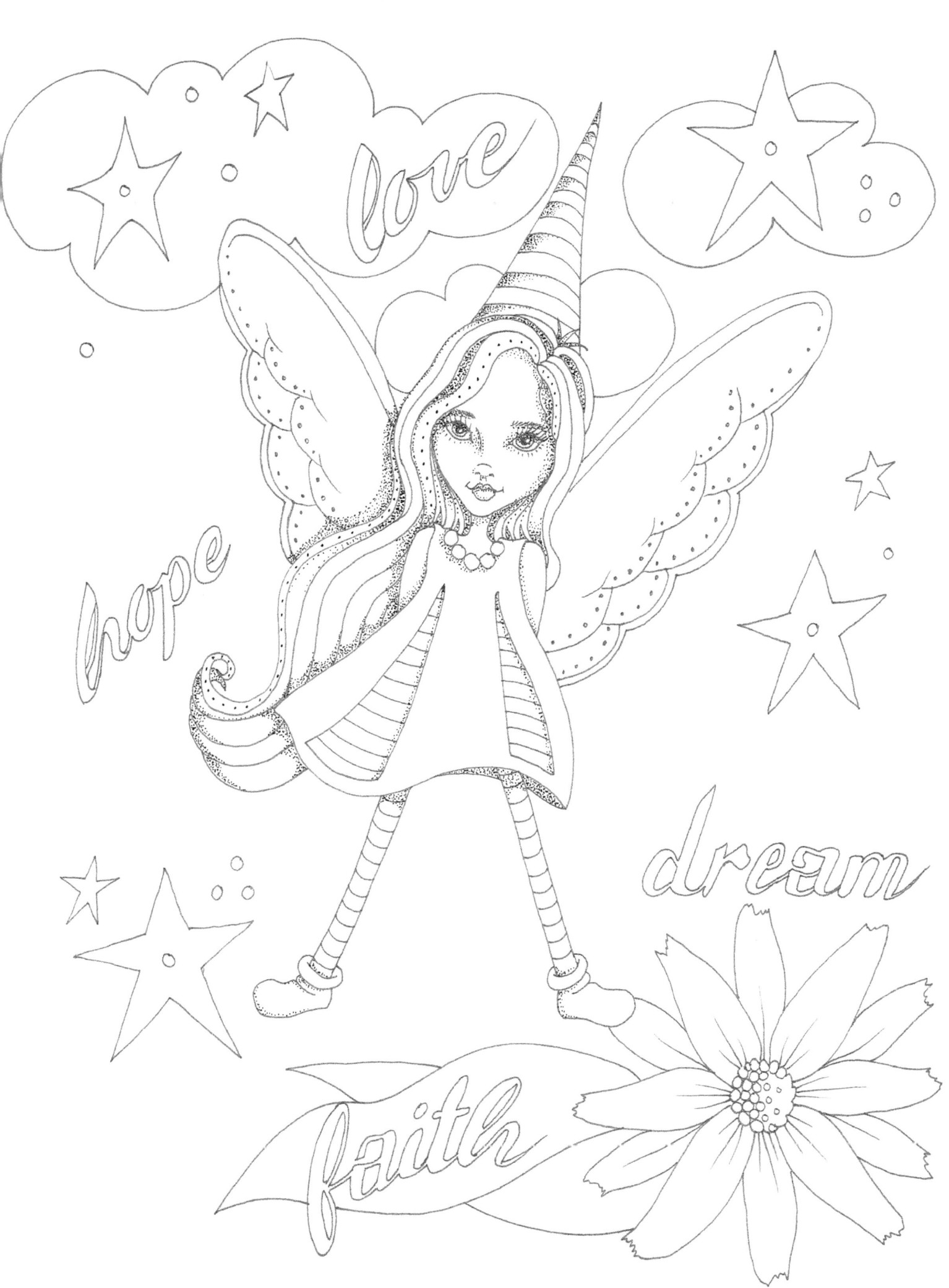

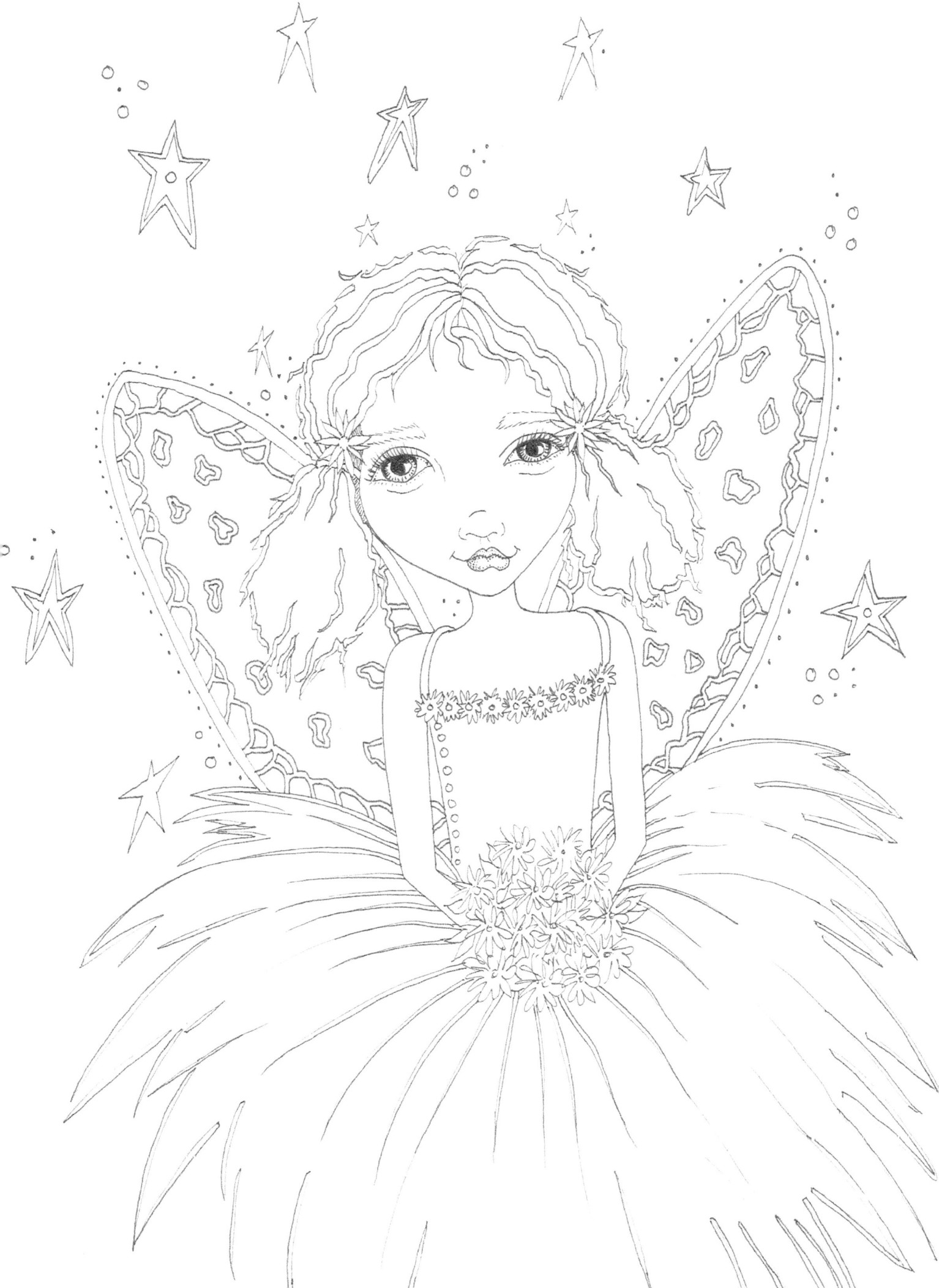

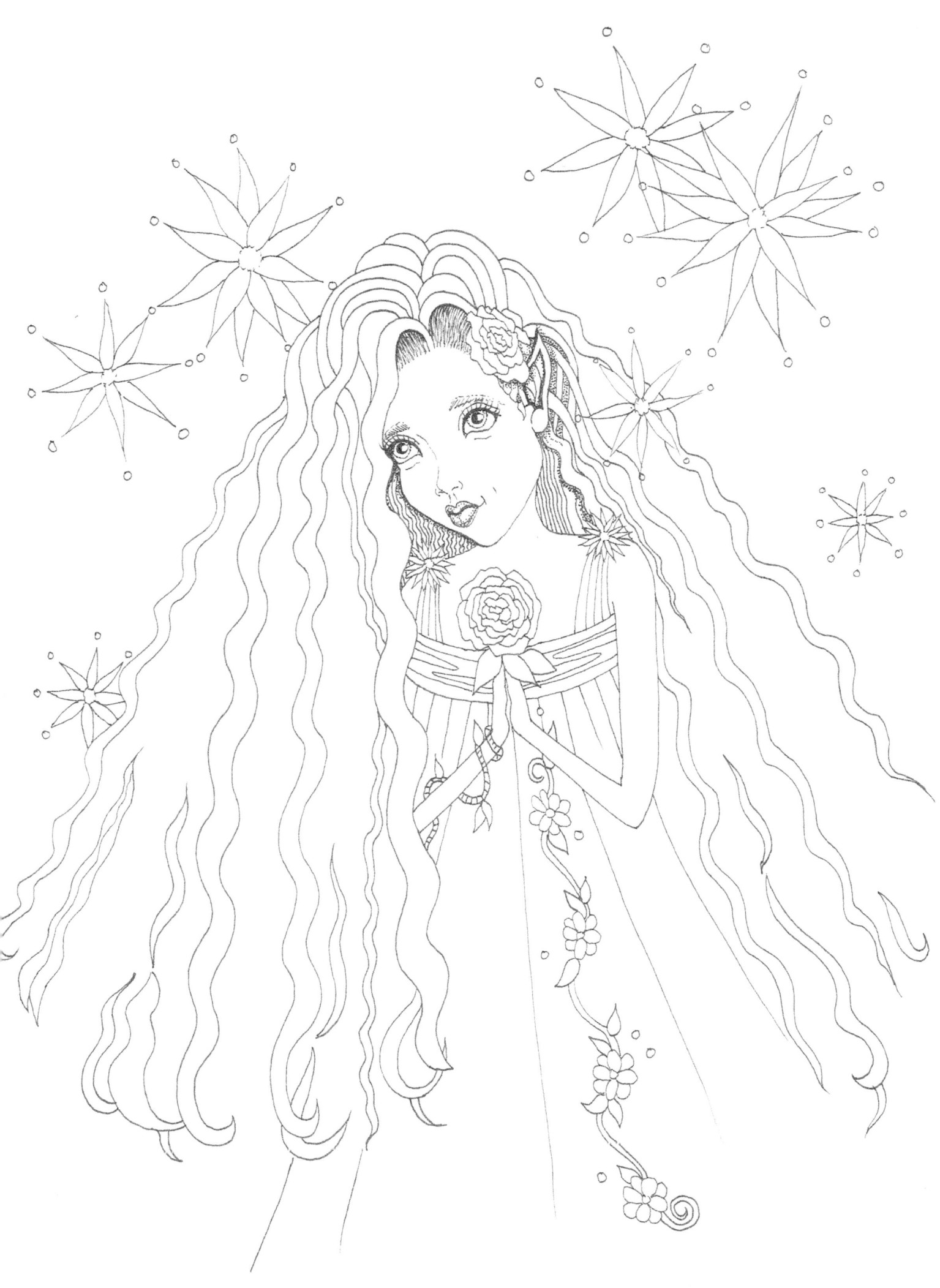

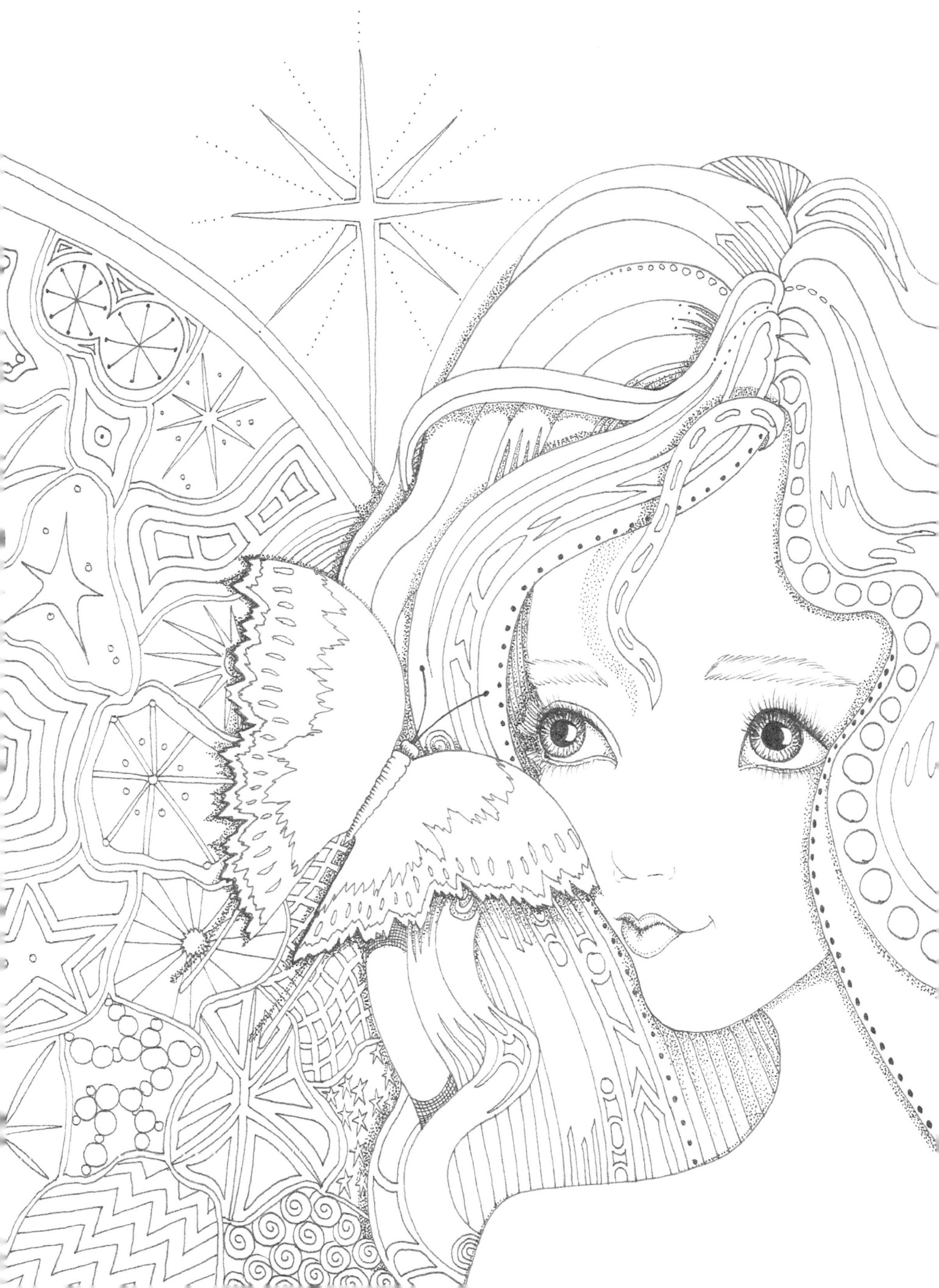

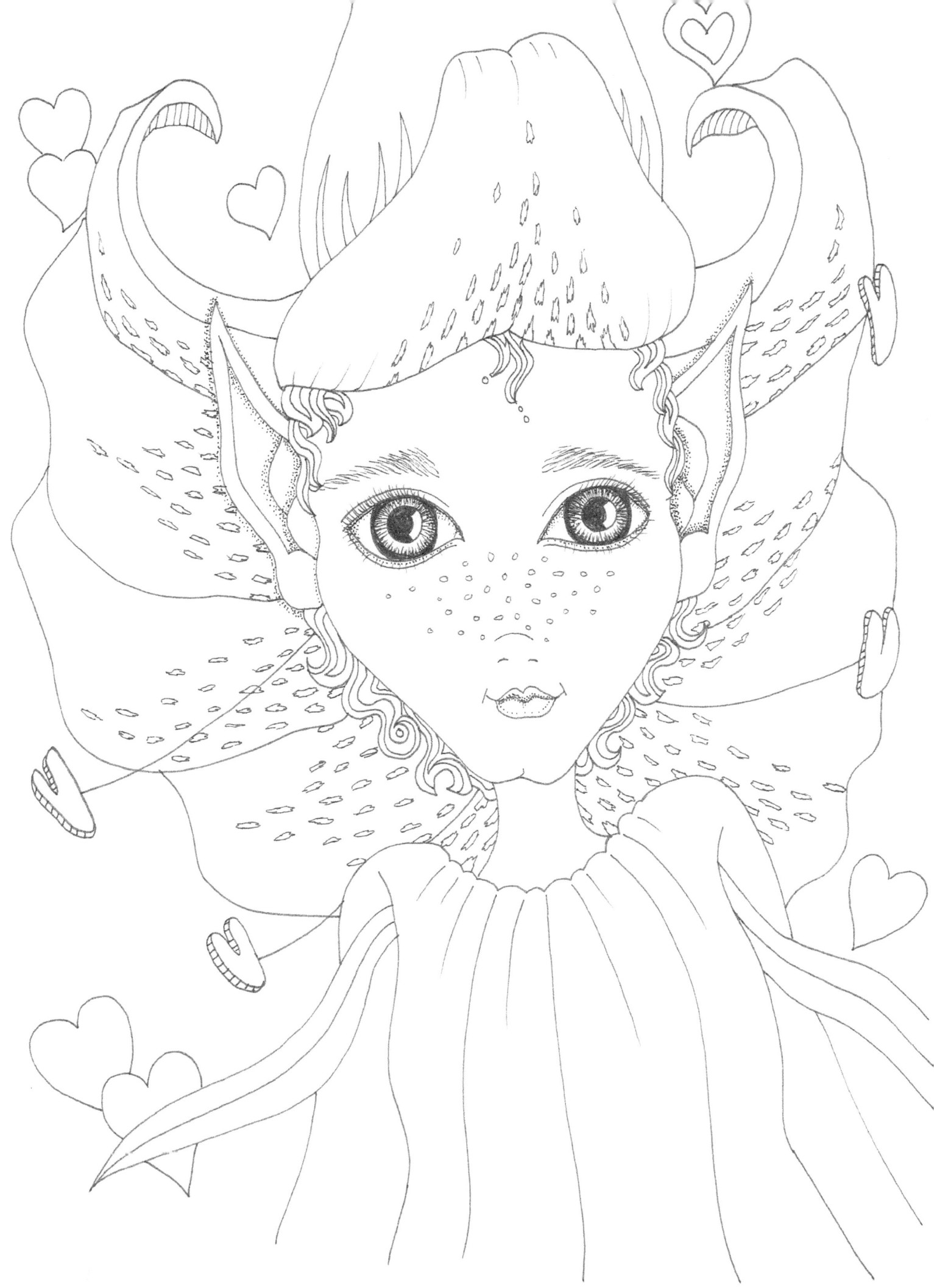

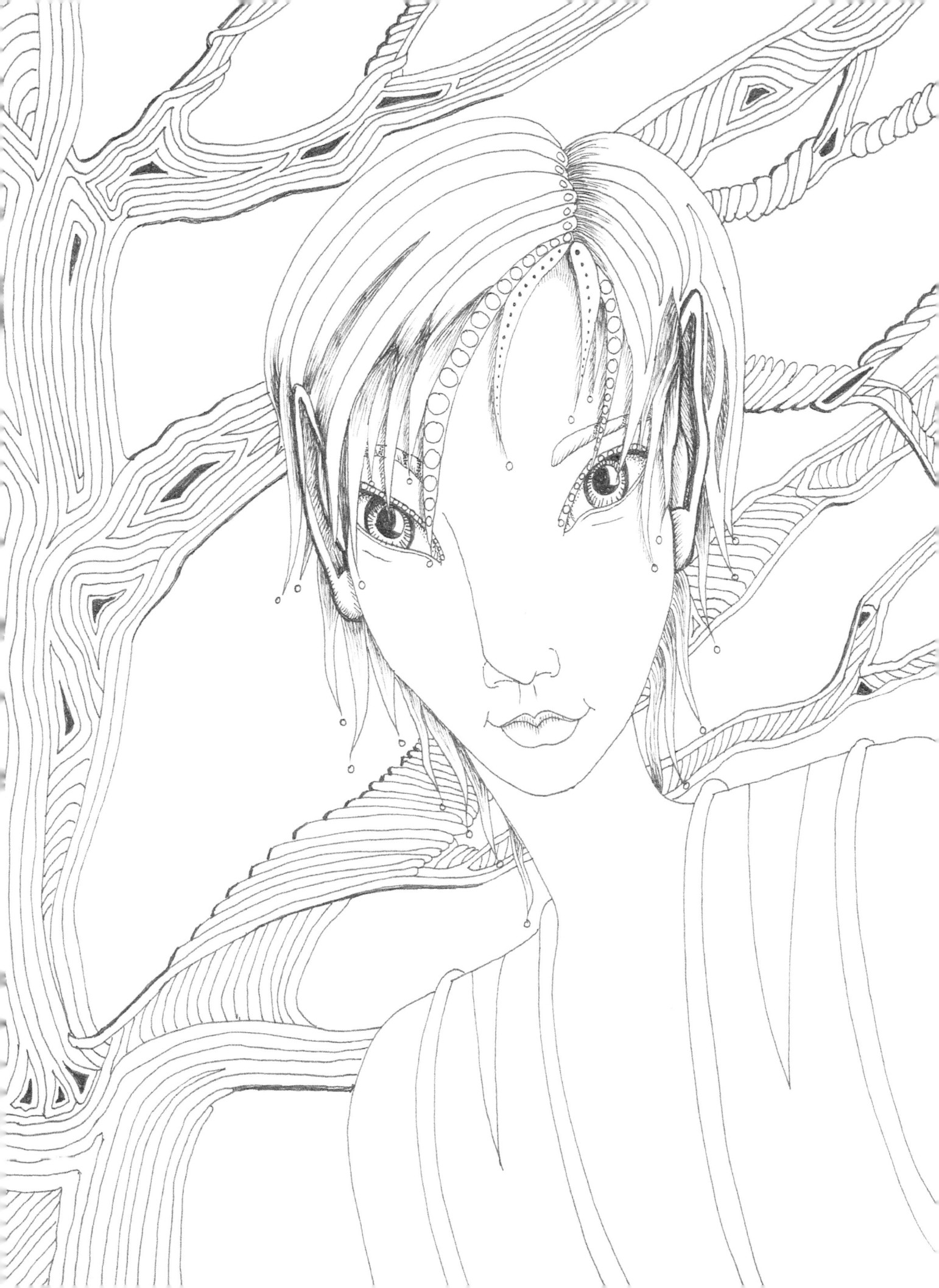

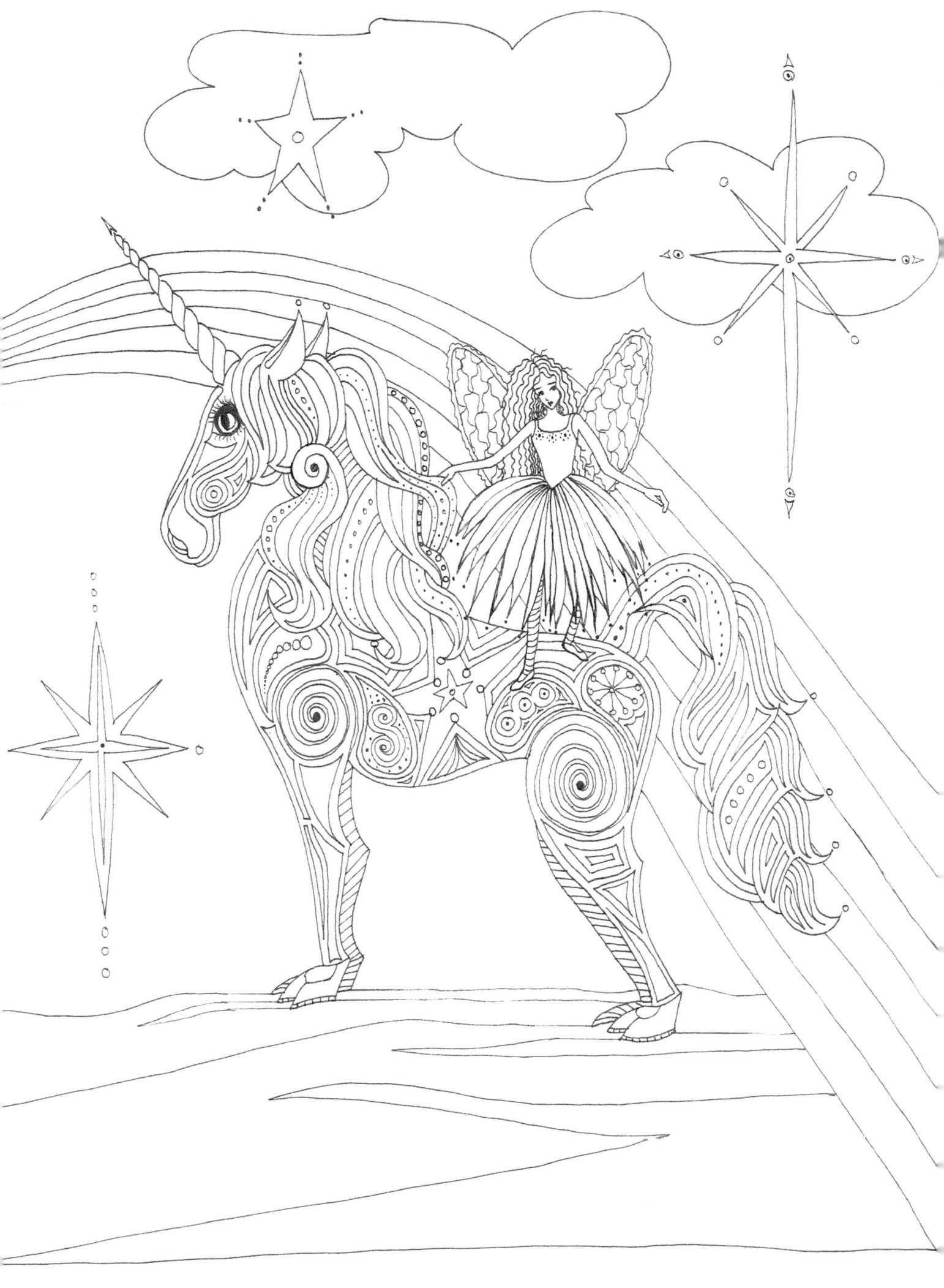

www.ingramcontent.com/pod-product-compliance
Lightning Source LLC
Chambersburg PA
CBHW080533190526
45169CB00008B/3142